VOLUME

She

delighting in the examples
of the women of the Bible

Delight Thyself
DESIGN MINISTRIES
delightthyself.com

Published by Delight In Him Publications,
a division of Delight Thyself Design Ministries in Hurricane, WV.

The mission of Delight Thyself Design Ministries is to design and distribute the printed Word of the Gospel of Jesus Christ.

Delight Thyself Design Ministries, Inc.
PO Box 725
Hurricane, WV 25526
delightthyself.com

Special thanks to those who gave their time as copy editors.

The contents of this book are the result of years of spiritual growth in life and ministry. Every effort has been made to give proper credit and attribution to quotes and information that is not original. It is not our intent to claim originality with any quote or thought that could not be tied to an original source.

Printed in the United States of America.

ISBN: 978-0-9995175-5-0

*To each of the Godly ladies
who have pointed me to His Word.*

*"She openeth her mouth with wisdom;
and in her tongue is the law of kindness."*
Proverbs 31:26

Also Available

Delight Thyself Also In The Lord:
a simple daily devotional

Order My Steps In Thy Word:
a verse by verse study of Psalm 119

Releasing Spring 2020

She:
Delighting In The Examples Of The Women Of The Bible

Volume 2
Anna
Eve
Hannah
Jochebed
Mary Magdalene
Naomi
Pharoah's Daughter
Ruth
Sapphira
The True Harlot Mother
The Widow With Two Mites
The Woman With An Issue Of Blood

Volume 3
Elisabeth
Gomer
Leah
Mary The Mother Of Jesus
Rachel
Rahab
Rhoda
Tabitha
Tamar
The Shunammite Woman
The Widow Of Nain
The Woman In Adultery

Volume 4
Delilah
Esther
Hagar
Herodias
Lot's Wife
Miriam
Rebekah
Sarah
The Maid By The Fire
The Queen Of Sheba
The Widow With Oil
The Woman With A Spirit Of Infirmity

VOLUME 1

The Women of the Bible

She...

The series of *She* consists of four volumes, each focusing on the lives of 12 women of the Bible. Many of the women are familiar, some less spoken of, but each are applicable to our lives today.

The objective of this series is not an effort to reveal some new theory about the women, but simply to point us to the pages of the Word of God so that the Lord can speak to us as only He can. Ask Him to show you the Truths found within the testimonies of each of these women that He has preserved for us to read.

Symbols:

The leaves around a name signify the beginning of the study of a new woman.

SHE...
This shows us a quality that we can apply to ourselves, or seek to become.

SHE...
This denotes a fact about them as women during their time in history.

Read

A suggested passage for the context of the study.

Memorize

Verse(s) to help apply the characteristics of the woman.

Apply

A question or two to encourage you to dwell on what can be learned from the example of the woman of the Bible.

Abigail

Abigail

1 Samuel 25:3

> **"...she was a woman of good understanding,
> and of a beautiful countenance..."**

SHE HAD BEAUTY AND BRAINS.

She was married to Nabal, a man churlish and evil,
who lived up to his name of being a fool.
She lived under excruciating circumstances having him as a husband.

1 Samuel 25:3

"Now the name of the man was Nabal; and the name of his wife _____: and

she was a woman of good understanding, and of a beautiful countenance: but the

man was churlish and _____ in his doings; and he was of the house of Caleb."

She was beautiful, however her beauty did not stop there.
She was not just a lovely face hiding an empty mind.

**A beautiful woman with a beautiful mind
was and is very uncommon.**

SHE WAS RESOURCEFUL.

When her husband spoke rudely and was unkind to King David's men, she took the
initiative to ask David to have mercy upon her unruly husband.

1 Samuel 25:24

"And fell _____ _____ _____, and said, Upon me, my lord,

upon me let this _____ be: and let thine handmaid,

I pray thee, speak in thine audience, and hear the words of thine handmaid."

SHE KNEW WHO DAVID WAS, AND BROUGHT HIM A BLESSING.

Her wisdom and understanding were evident as she pleaded for his forgiveness. She
had heard of his battle with Goliath, and how the Lord brought him victory through a
sling. She asked him to remember her.

1 Samuel 25:32-33

"And David said to Abigail, _____ be the LORD God of Israel, which sent thee this day to meet me: And blessed be thy _____, and blessed be thou, which hast kept me this day from coming to shed blood, and from avenging myself with mine own hand."

SHE MADE AN IMPRESSION UPON DAVID.

Nabal died shortly after this encounter. When David heard the news, he sent his servants for Abigail, and she became his wife.

She...

ABIGAIL SERVES AS AN EXAMPLE
OF HOW WE CAN BE BEAUTIFUL
BOTH BEFORE MEN AND BEFORE THE LORD.

Memorize:

Proverbs 31:30
*"Favour is deceitful, and beauty is vain: but **a woman that feareth the LORD, she shall be praised.**"*

Apply:

What characteristics about Abigail would you like to have?

Where did she fall when she pleaded with David?
1 Samuel 25:24

She is a picture of how we should approach the Lord.

Bathsheba

Bathsheba

2 Samuel 11:4

"...she returned unto her house."

SHE WAS THE WIFE OF URIAH THE HITTITE.

2 Samuel 11:2

"And it came to pass in an eveningtide, that _____ arose from off his bed, and walked upon the roof of the king's house: and from the roof he saw a woman washing herself; and the woman was very _____ to look upon."

King David saw her from his rooftop
and the lust of his flesh took over.

2 Samuel 11:3

"And David sent and _____ after the woman. And one said, Is not this Bathsheba, the daughter of Eliam, the wife of Uriah the Hittite?"

SHE COULD HAVE RESISTED THE TEMPTATION.

King David enquired after her, even though she was someone else's wife.
She submitted to the king's request, and came to him.

2 Samuel 11:4-5

"And David sent messengers, and took her; and she came in unto him, and he lay with her; for she was purified from her uncleanness: and she _____ unto her house. And the woman conceived, and sent and told David, and said, I am with _____."

SHE CONCEIVED A CHILD THROUGH ADULTERY.

After King David received the news, he sealed the fate of Uriah
by assigning him to a place of war where valiant men were.

2 Samuel 11:26

"And when the wife of Uriah heard that Uriah her husband was dead, she _____ for her husband."

She found out that her sin
had cost her husband his life.

2 Samuel 11:27

"And when the mourning was past, David sent and fetched her to his house, and she became his _____, and bare him a son. But the thing that David had done _____ the LORD."

Afterwards David sent for her again, and she became his wife.
But the LORD was not pleased.

She...

BATHSHEBA SERVES AS AN EXAMPLE
OF HOW OUR SIN HAS CONSEQUENCES WHEN
WE GIVE IN TO TEMPTATION.

Memorize:
Galatians 6:7-8
"Be not deceived; God is not mocked: **for whatsoever a man soweth, that shall he also reap.** *For he that soweth to his flesh shall of the flesh reap corruption; but he that soweth to the Spirit shall of the Spirit reap life everlasting."*

Apply:
How can we learn from Bathsheba to avoid giving into temptation?

2 Samuel 12:24

"...she bare a son, and he called his name Solomon..."

SHE HAD LOST HER FIRST SON.

2 Samuel 12:15

"And Nathan departed unto his house. And the LORD _____ the child

that Uriah's wife bare unto David, and it was _____ sick."

The child that was conceived through adultery died.

2 Samuel 12:23

"But now he is dead, wherefore should I fast? can I bring him back again?

I shall _____ to him, but he shall not _____ to me."

SHE AND HER HUSBAND REPENTED OF THEIR SIN.

Psalm 51:1

"Have _____ upon me, O God, according to thy _____:

according unto the multitude of thy tender mercies blot out my _____."

SHE WAS GIVEN ANOTHER SON.

She was comforted by her husband after the death of their first child. God blessed them with another son, Solomon, a son of wisdom who would one day be king after his father.

Repentance makes a difference.

SHE IS MENTIONED IN THE GENEOLOGY OF JESUS.

Matthew 1:6

"And Jesse begat David the king;

and David the king begat _____ of her that had been the wife of Urias;"

Read: Proverbs 31

She was once known as an adulteress,
but afterward as virtuous and wise in the last chapter of Proverbs.

She...

BATHSHEBA ALSO SERVES AS AN EXAMPLE THAT GOD OFFERS US TRUE FORGIVENESS WHEN WE REPENT OF OUR SINS.

Psalm 51:10

"Create in me a _____ heart, O God;
and renew a right spirit _____ me."

Our mistakes do not have to ruin our entire life.
We can instead use the lessons we learn
to encourage others to refrain from the same faults.

Psalm 51:13

"Then will I _____ transgressors thy ways;
and _____ shall be converted unto thee."

Memorize:
1 John 1:9
*"If we confess our sins, **he is faithful and just to forgive us our sins**, and to cleanse us from all unrighteousness."*

Apply:
What do you need to confess? He is faithful and ready to forgive.

Deborah

Judges 4:4

"...she judged Israel at that time."

SHE WAS A LEADER.

Judges 4:4

"And Deborah, a prophetess, the _____ of Lapidoth,

she_____ Israel at that time."

SHE WAS A PROPHETESS.
This means the Lord had gifted her with the ability to discern
the purpose of God and declare it to others.

She judged in a time when men did that which was right in their own eyes.
Judges 17:6

SHE IS THE ONLY WOMAN TO JUDGE ISRAEL, RECORDED IN SCRIPTURE.

She called for Barak to go unto Mount Tabor and defeat Jabin's army. Barak knew they
would be outnumbered, and was only willing to go if she went with him.
She led by faithfully doing as she said she would do.

Judges 4:8

"And Barak said unto her, If thou wilt _____ with me, then I will go:

but if thou wilt not go with me, then I will _____ go."

SHE GAVE THE LORD THE GLORY.

Judges 4:9

"And she said, I will _____ go with thee:

notwithstanding the _____ that thou takest shall not be

for thine honour; for the LORD shall sell Sisera into the hand of a woman.

And Deborah _____, and went with Barak to Kedesh."

SHE LED BY PRAISING THE LORD.

Judges 5:1-3

"Then sang Deborah and Barak the son of Abinoam on that day,

saying, _____ ye the LORD for the avenging of Israel, when the people

_____ offered themselves. Hear, O ye kings; give ear, O ye princes;

I, even I, will sing unto the LORD; I will sing praise to the LORD God of Israel."

She faithfully fixed her heart upon the Lord.

She...

DEBORAH SERVES AS AN EXAMPLE THAT WE CAN BE ENABLED BY THE LORD TO LEAD OTHERS.

She faithfully went to battle with a sword in her hand,
and sang praises unto the Lord for His provision.

**We can choose to carry the Sword of the Spirit with us in our battles,
while singing a song of praise unto Him for His glory and grace.**

Memorize:
Psalm 31:3
*"For thou art my rock and my fortress; **therefore for thy name's sake lead me, and guide me.**"*

Apply:
What is most interesting to you about Deborah?

How can you be a leader?

Lydia

Read : Acts 16:11-14

Lydia

Acts 16:14

"...she attended unto the things which were spoken of Paul."

SHE WAS RELIGIOUS.

She was among the group of women
who gathered on the Sabbath by a river side to pray.

Acts 16:13
"And on the sabbath we went out of the city by a river side,

where _____ was wont to be made;

and we sat down, and _____ unto the women which resorted thither."

When Paul and Silas visited the women,
Lydia was attentive and heard the Gospel that Paul preached.

SHE IS KNOWN AS THE SELLER OF PURPLE.

This meant she sold either fine purple cloth or the dye itself.
No husband is mentioned, so she may have been a single woman.

Acts 16:14

"And a certain woman named Lydia, a seller of _____, of the city of Thyatira,

which _____ God, heard us..."

SHE TRADED RELIGION FOR RELATIONSHIP.

Acts 16:14

"...whose_____ the Lord opened,

that she _____ unto the things which were spoken of Paul."

SHE WAS THE FIRST CONVERT OF PAUL IN EUROPE AFTER HE HAD THE MACEDONIAN VISION.

She...

LYDIA SERVES AS AN EXAMPLE THAT RELIGION DOES NOT MEAN THAT WE HAVE A RELATIONSHIP WITH THE LORD.

There is a difference in knowing something, and actually believing, or placing your faith in it.

The phrase "18 inches away from Heaven" applies to many people today. Many may know of Jesus without knowing Him personally as their Saviour.

Memorize:

James 1:22

*"But **be ye doers of the word**, and not hearers only, deceiving your own selves."*

Apply:

What example have you seen of religion rather than relationship?

Acts 16:15

"...she was baptized, and her household..."

SHE WAS BAPTIZED IMMEDIATELY.

It was a public confession of the inward transformation
that had taken place within her.

She provided housing for Paul and Silas when they were in Philippi.

Acts 16:15

"*...she besought us, saying, If ye have judged me to be _____ to the*

Lord, come into my house, and abide there. And she _____ us."

Paul planted a church in Philippi.
It is likely that the church began in Lydia's house.

He and Silas were imprisoned while they were there.
The Philippian Jailor was converted as a result of their stay.

They returned to a familiar house after they were miraculously released.

Acts 16:40

"*And they went out of the prison, and entered into the house of _____:*

and when they had seen the _____, they comforted them, and departed."

Paul wrote a letter, that we know as the Book of Philippians,
while he was in prison in Rome.

Acts 16:12
"*And from thence to _____, which is the chief city of that part of Macedonia,*
and a colony: and we were in that city abiding certain days."

As you read through Philippians, read with Lydia in mind.

SHE HAD A GREAT IMPACT ON THE CHURCH.

She had a part in it being started and sustained in Philippi, so it is likely that when
Paul refers to the women who laboured with him, he is referring directly to her.

Philippians 4:3

"And I intreat thee also, true yokefellow, help those _____

which laboured with me in the _____, with Clement also,

and with other my _____, whose names are in the book of life."

SHE WAS A SUPPORTER OF MISSIONS.

As a seller of purple, she was a successful businesswoman who was likely very wealthy. This enabled her to give to the missionaries she often hosted in her home.

Read : Philippians 4:15-19

SHE WAS A SOUL WINNER.

She must have told all that were in her household what the Lord had done for her. Her household was also baptized.

A mark of a true conversion is the desire to tell others.

She...

LYDIA SERVES AS AN EXAMPLE OF THE EFFECTS THAT THE GOSPEL CAN HAVE ON OUR LIVES.

Memorize :
Proverbs 11:30
*"The fruit of the righteous is a tree of life; and **he that winneth souls is wise.**"*

Apply :
What does Lydia inspire you to do?

Martha

Luke 10:39

> ## "...she had a sister called Mary, which also sat at Jesus' feet, and heard his word."

SHE WAS THE SISTER OF MARY OF BETHANY.
Lazarus was their brother.

SHE RECEIVED JESUS INTO HER HOUSE.

This is the first mention of Martha.

Luke 10:38
"Now it came to pass, as they went, that he entered into a certain village:

and a certain woman named Martha _____ him into her house."

While Jesus was there, they would **both** sit at His feet
to hear Him speak Words of Wisdom.

Luke 10:39

"...which _____ sat at Jesus' feet, and heard his word."
This phrase tells us that Mary was not the only one who sat at His feet.

Martha was there too at some point.

SHE HAD A DESIRE TO SERVE MUCH
BECAUSE SHE HEARD HIS WORD.

Luke 10:40

"But Martha was _____ about much serving..."

SHE SOMETIMES COMPLAINED WHILE SHE SERVED.

When we focus on ourselves as we serve, we have lost the purpose of serving.

Luke 10:40

"...and came to him, and said, Lord, dost thou not _____ that my sister hath

left me to serve alone? bid her therefore that she help me."

SHE DARED TO ASK JESUS IF HE CARED ABOUT HER SITUATION.

Our pride can make us ask some dumb questions.

Did He care? Does He care for us?

1 Peter 5:7

"Casting all your care upon him; for he _____ for you."

SHE WAS REBUKED BY THE WORD.

Luke 10:41

"And Jesus answered and said unto her,

Martha, Martha, thou art _____ and troubled about _____ things:"

There is only one thing we are to be careful about.

Philippians 4:6

"Be careful for _____; but in every thing by prayer and supplication

with thanksgiving let your _____ be made known unto God."

SHE LATER REMEMBERED TO RETURN TO THE FEET OF JESUS.

MARTHA SERVES AS AN EXAMPLE THAT SITTING AT THE FEET OF JESUS WILL GIVE US THE DESIRE TO SERVE HIM.

Memorize:
1 Samuel 12:24
*"Only fear the LORD, and **serve him in truth with all your heart**:
for consider how great things he hath done for you."*

Apply:
How can you serve Him more?

John 11:20

"...she heard that Jesus was coming..."

SHE HEARD HIS WORD AND CHOSE TO FAITHFULLY SERVE HIM.

Luke 10:40

"But Martha was cumbered about much _____..."

SHE HAD A HISTORY OF BEING MOVED TO ACTION BY HER LOVE FOR JESUS.

John 11:5

"Now Jesus _____ Martha, and her sister, and Lazarus."

When Lazarus was sick, his sisters sent word to Jesus;
but their brother died before He came to Bethany.

John 11:20

"Then Martha, as _____ as she heard that Jesus was coming,

went and _____ him: but Mary sat still in the house."

SHE IMMEDIATELY WENT TO MEET HIM.
Instead of waiting for Him to come, she sprang into action.

SHE HAD FAITH THAT HE COULD MAKE A DIFFERENCE.

John 11:21-22

"Then said Martha unto Jesus, Lord, if thou hadst been _____, my brother

had not died. But I know, that even now, whatsoever thou wilt _____ of God,

God will _____ it thee."

SHE WAS THE FIRST TO HEAR THAT LAZARUS WOULD LIVE AGAIN.

John 11:23

"Jesus saith unto her, Thy brother shall _____ again."

He saw her faith.

SHE WAS ALWAYS FOUND SERVING.

The last time she is mentioned she served supper.

John 12:2

"There they made _____ a supper; and Martha served:

but Lazarus was one of them that sat at the _____ with him."

MARTHA ALSO SERVES AS AN EXAMPLE OF HOW WE SHOULD BE ACTIVELY WORKING AS WE WAIT FOR CHRIST TO COME AGAIN.

Memorize:

1 Corinthians 15:58
*"Therefore, my beloved brethren, **be ye stedfast, unmoveable, always abounding in the work of the Lord**, forasmuch as ye know that your labour is not in vain in the Lord."*

Apply:

What could you be doing while you wait?

John 11:27

> ## *"She saith unto him, Yea, Lord:*
> ## *I believe that thou art the Christ, the Son of God"*

SHE HEARD THE GOSPEL.

John 11:25-26

"Jesus said unto her, I am the _____, and the life:

he that _____ in me, though he were dead, yet shall he live:

And _____ liveth and believeth in me shall never die.

Believest _____ this?"

SHE TRUTHFULLY ANSWERED THE QUESTION
THAT JESUS ASKED HER.

He asked the question after He had stated Who He was
and what He could do for her and the rest of the world **if only** they believe.

This same question is asked to every person He has created.
"Believest thou this?"

SHE GAVE THE BEST ANSWER.

John 11:27

"Yea, Lord: I _____ that thou art the Christ, the Son of God..."

SHE BELIEVED IN HIM.

"Believest thou this?"
Every aspect of our walk with the Lord is based upon our answer to this question.

Our faith in Him is everything.

She...

MARTHA ALSO SERVES AS AN EXAMPLE OF HOW THE LORD DESIRES EACH OF US TO BELIEVE IN HIM.

SHE WENT TO TELL MARY.

John 11:28

"And when she had so said, she _____ her way, and called

Mary her sister secretly, saying, The Master is come, and _____ for thee."

May our faith cause us to want to tell someone else about Him.

Memorize:
John 3:16
*"For God so loved the world, that he gave his only begotten Son, that **whosoever believeth in him** should not perish, but have everlasting life."*

Apply:
What are you asking the Lord to do for you?

Do you believe He is Able to do it? _____

Who do you need to tell about Him?

Mary of Bethany

Read: Matthew 26:1-13
Mark 14:1-9
John 12:1-8

Mary of Bethany

Mark 14:3

"...she brake the box, and poured it on his head."

SHE SACRIFICED FOR A PURPOSE.

SHE POURED THE OIL ON HIS HEAD IN MATTHEW & MARK.

Matthew 26:6-7

"Now when Jesus was in _____, in the house of Simon the leper,

There came unto him a woman having an _____ box

of very precious ointment, and poured it on his head, as he sat at meat."

Mark 14:3

"And being in Bethany in the house of Simon the leper, as he sat at meat, there came

a woman having an alabaster box of ointment of _____ very precious;

and she _____ the box, and poured it on his head."

SHE ANOINTED HIS FEET IN JOHN.

John 12:3

"Then took Mary a _____ of ointment of spikenard, very costly,

and anointed the feet of Jesus, and wiped his _____ with her hair:

and the house was filled with the _____ of the ointment."

SHE GAVE THE SAVIOUR EVERYTHING SHE HAD.

Matthew 26:12

"For in that she hath_____ this ointment on my body, she did it for my burial."

May we pour out our lives in service to Him.

SHE KNEW HE WOULD NOT BE WITH THEM MUCH LONGER.

Matthew 26:11

"For ye have the poor always with you; but _____ ye have not always."

SHE WAS RIDICULED FOR WHAT SHE DID.

Matthew 26:8-9

"But when his disciples saw it, they had indignation, saying,

To what purpose is this _____? For this ointment

might have been _____ for much, and given to the poor."

Have you ever felt such criticism?

SHE WILL ALWAYS BE REMEMBERED FOR HER SACRIFICE.

Matthew 26:13

"Verily I say unto you, Wheresoever this _____ shall be preached

in the whole world, there shall also this, that this _____ hath done,

be told for a _____ of her."

She...

MARY OF BETHANY SERVES AS AN EXAMPLE THAT SACRIFICING FOR HIM IS ALWAYS WORTH THE COST.

Memorize:
Galatians 6:9
*"And **let us not be weary in well doing**: for in due season we shall reap, if we faint not."*

Apply:

We will be criticized. Is quitting worth missing out on giving Him the glory He deserves?

Mary of Bethany

Mark 14:8

"She hath done what she could..."

SHE HAD SOMETHING TO GIVE.

Matthew 26:7

"There came unto him a woman having an _____ box

of very _____ ointment, and poured it on his head, as he sat at meat."

While others criticized, Jesus commended her.

Matthew 26:10

"When Jesus understood it, he said unto them, Why _____ ye the woman?

for she hath wrought a _____ work upon me."

SHE SIMPLY DID WHAT SHE COULD FOR CHRIST.

Mark 14:8

"She hath done what she could:

she is come aforehand to anoint my body to the _____."

Should this not be our prayer for our own lives?
Oh that we would just do what we can for Him!

Mark 14:9

"Verily I say unto you, Wheresoever this gospel

shall be preached _____ the whole world, this also

that she hath done shall be _____ of for a memorial of her."

SHE IS STILL REMEMBERED FOR WHAT SHE DID.

What will you be remembered for?

She...

MARY OF BETHANY ALSO SERVES AS AN EXAMPLE THAT IF WE WILL SIMPLY DO WHAT WE CAN, HE CAN DO THE IMPOSSIBLE.

We all have something to give.
Our time.
Our talents.
Our service.

When we give whatever we have to Him, we allow Him to work through us.

Memorize:

Romans 12:1
*"I beseech you therefore, brethren, by the mercies of God, that ye present your bodies a living sacrifice, holy, acceptable unto God, **which is your reasonable service.**"*

Apply:

What is it that you could give?

How does Mary of Bethany's sacrifice and service inspire you?

John 11:29

"...she arose quickly, and came unto him."

SHE WAS WAITING FOR JESUS TO COME.

John 11:20

"Then Martha, as soon as she heard that Jesus was coming, went and met him:

but Mary sat _____ in the house."

SHE WAS TOLD THAT JESUS HAD CALLED FOR HER.

John 11:28

"And when she had so said, she went her way,

and called Mary her sister _____, saying,

The Master is come, and calleth for thee."

Martha spoke with Him when she arrived, but there is no written record of Jesus asking for Mary or calling for her to come to Him.

**Yet, the moment she was told that Jesus called for her,
she immediately went to Him.**

John 11:29

"As _____ as she heard that, she arose quickly, and came unto him."

SHE LOVED THE LORD.

Luke 10:39

"And she had a _____ called Mary,

which also sat at Jesus' feet, and _____ his word."

SHE WAS FAITHFULLY AT HIS FEET.

Her love for Him gave her a desire to hear His Word.

SHE WAS FAITHFUL TO OBEY AND WORSHIP HIM.

Luke 10:42

"But _____ thing is needful:

and Mary hath _____ that good part,

which shall not be taken away from her."

Today, and every day, may we choose to love and worship our Saviour just as she so faithfully did.

She...

MARY OF BETHANY ALSO SERVES AS AN EXAMPLE OF HOW WE MUST NOT DELAY IN COMING TO HIM.

Memorize:
Matthew 6:33
*"But **seek ye first the kingdom of God**, and his righteousness; and all these things shall be added unto you."*

Apply:
How has delaying to come to Him affected you before?

What do you need to bring to Him today?

John 11:32

"...she fell down at his feet..."

SHE WAS ONCE AGAIN AT HIS FEET.

John 11:32

"Then when Mary was come where Jesus was, and saw him, she _____ down

at his feet, saying unto him, Lord, if thou hadst been _____,

my brother had not died."

SHE HAD FAITH THAT HE COULD HAVE HEALED HER BROTHER.

Jesus came, but Lazarus had been dead four days.

SHE SPOKE THROUGH HER TEARS.

John 11:33-34

"When Jesus therefore saw her _____, and the Jews also weeping

which came with her, he groaned in the spirit,

and was _____, And said, Where have ye laid him?

They said unto him, Lord, come and see."

Jesus was moved with compassion.

John 11:5

"Now Jesus _____ Martha, and her sister, and Lazarus."

John 11:35

"Jesus _____."

SHE SAW HIS TEARS.

Can you imagine seeing your Saviour cry because He cares for you that much?

SHE COMPELLED JESUS TO DO SOMETHING.

John 11:39

"Jesus said, Take ye away the _____*..."*

John 11:43

"And when he thus had spoken, he cried with a loud voice,

Lazarus, _____ forth."

SHE WITNESSED JESUS RAISING LAZARUS FROM THE DEAD.

This miracle brought many people to Jesus.

She...

MARY OF BETHANY ALSO SERVES AS AN EXAMPLE OF THE DIFFERENCE HE CAN MAKE IN OUR LIVES WHEN WE ARE WILLING TO FALL AT HIS FEET.

Memorize:
Hebrews 4:16
*"Let us therefore **come boldly unto the throne of grace**, that we may obtain mercy, and find grace to help in time of need."*

Apply:
What can you bring to His feet today?

Michal

Michal

2 Samuel 6:16

> ## *"...she despised him in her heart."*

She was the daughter of Saul, the jealous archrival of King David.

SHE WAS DAVID'S FIRST WIFE.

She saw her husband praising the Lord as the Ark arrived.

2 Samuel 6:17

"And they brought in the _____ of the LORD, and set it in his place,

in the midst of the tabernacle that David had pitched for it: and David offered

_____ offerings and _____ offerings before the LORD."

SHE WAS OBSERVANT.

She watched as he offered offerings and blessed the people.

2 Samuel 6:18

"And as soon as David had made an _____ of offering burnt offerings and

peace offerings, he blessed the people in the _____ of the LORD of hosts.

SHE REVILED HIM FOR HUMBLING HIMSELF
BEFORE THE LORD AS HE WORSHIPPED.

2 Samuel 6:20

"Then David returned to bless his _____. And Michal the daughter of

Saul came out to meet David, and said, How _____ was the king of

Israel to day, who uncovered himself to day in the eyes of the _____ of his

servants, as one of the vain fellows shamelessly uncovereth himself!"

2 Samuel 6:21

"And David said unto Michal, It was _____ the LORD, which chose me

before thy father, and before all his house, to appoint me _____ over the

people of the LORD, over Israel: therefore will I play before the LORD."

She mocked his humility as he honored the Lord.
She did not understand.

1 Corinthians 2:14

"But the natural man _____ not the things of the Spirit of God:

for they are foolishness unto him: neither can he _____ them,

because they are _____ discerned."

She...

MICHAL SERVES AS AN EXAMPLE OF THOSE
THAT PERSECUTE PEOPLE
WHO ARE SINCERE IN THEIR WORSHIP.

Those that complain and criticize are often those
that watch rather than participating.

Memorize:
Proverbs 14:2
"He that walketh in his uprightness feareth the LORD:
*but **he that is perverse in his ways despiseth him.**"*

Apply:
How have you been persecuted for your faith?

Phebe

Phebe

Romans 16:2

> **"...she hath been a succourer of many,
> and of myself also."**

She was a sister in the faith, both to Paul and to the church.

She was a servant.

Romans 16:1

"I commend unto you Phebe our sister, which is a _____ of the church

which is at Cenchrea:"

Although she was from the area of Corinth, she journeyed to Rome.

She was willing to serve anywhere, and with anything.

So much so, that the Apostle Paul pleads with the church at Rome
to receive her and assist her in anything she needed.

Romans 16:2

"That ye _____ her in the Lord, as becometh saints,

and that ye assist her in whatsoever _____ she hath need of you:

for she hath been a succourer of _____, and of myself also."

She was a succourer.

**She not only cared for the needs of others,
but also aided them with her own resources.**

This word, *"succourer"*, is only used in reference to Phebe.
Nowhere else is the term mentioned within the Scriptures.

What a special commendation for such a faithful helper.
She cared for many, but Paul specifically mentions that she cared for him.
Thus the reason that he saw fit to include in his letter to the Romans
that they help her as she had helped him and so many others.

She...

PHEBE SERVES AS AN EXAMPLE THAT

WHEN WE SERVE THE LORD,

OUR LABOUR IS NOT IN VAIN.

1 Corinthians 15:58

"Therefore, my beloved brethren, be ye stedfast, _____,

always _____ in the work of the Lord, forasmuch as ye know

that your labour is not in vain in the Lord."

Memorize:
Galatians 6:9
*"And **let us not be weary in well doing**: for in due season we shall reap,
if we faint not."*

Apply:
How can you be a succourer to those around you?

What characteristics of Phebe would you like to have?

The Syrophenician Woman

The Syrophenician Woman

Matthew 15:27

"...she said, Truth, Lord: yet the dogs eat of the crumbs which fall from their masters' table."

SHE CRIED UNTO THE LORD.

There is purpose in praying.
If we are to be women of purpose, we must pray.

Matthew 15:22

"And, behold, a woman of _____ came out of the same coasts,

and cried unto him, saying,

Have _____ on me, O Lord, thou Son of David;

my daughter is grievously _____ with a devil."

SHE FELL AT HIS FEET IN HUMBLE DESPERATION.

Mark 7:25-26

"For a certain woman, whose young daughter had an _____ spirit,

heard of him, and came and fell at _____ feet: The woman was a Greek,

a Syrophenician by nation; and she besought him

that he would cast _____ the devil out of her daughter."

SHE DID NOT RECEIVE AN ANSWER IMMEDIATELY.

Matthew 15:23

"But he _____ her not a word. And his disciples came and besought

him, saying, _____ her away; for she crieth after us."

The Lord always answers our prayers.
Sometimes He says, "No." Sometimes He says, "Yes."
Sometimes He says, "Wait."

SHE KEPT PRAYING.

SHE PERSISTENTLY PRAYED FOR HER NEED.

Matthew 15:25

"Then came she and worshipped him, saying, Lord, _____ me."

The waiting did not shake her faith.

Matthew 15:26
"But he answered and said,

It is not meet to take the children's _____, and to cast it to dogs."

Matthew 15:28
"Then Jesus answered and said unto her,

O woman, great is thy _____: be it unto thee even as thou wilt.

And her daughter was made _____ from that very hour."

She returned home and found her daughter healed.
He answered her prayer.

She...

THE SYROPHENICIAN WOMAN SERVES

AS AN EXAMPLE OF HOW

WE SHOULD BE PERSISTENT IN OUR FAITH.

Memorize:
Matthew 21:22
*"And all things, whatsoever ye shall ask in prayer, **believing**, ye shall receive."*

Apply:
What are you persistently praying about?

The Virtuous Woman

The Virtuous Woman

Proverbs 31:26

> *"She openeth her mouth with wisdom;*
> *and in her tongue is the law of kindness."*

SHE WAS THE MOTHER OF KING LEMUEL, MOST LIKELY WHO WE KNOW AS SOLOMON.

If this truly is Solomon, that means the mother here is Bathsheba.
She is most well known for her adulterous affair with David,
yet here we find her called a Virtuous Woman.

SHE IS MORE PRECIOUS THAN RUBIES.
Proverbs 31:10

"Who can find a virtuous woman? for her _____ is far above rubies."

SHE IS TRUSTED BY HER HUSBAND.
Proverbs 31:11

"The _____ of her husband doth safely trust in her,

so that he shall have no need of spoil."

SHE IS FAITHFUL TO HER HUSBAND.
Proverbs 31:12

"She will do him _____ and not evil all the days of her life."

SHE WORKS WILLINGLY WITH HER HANDS.
Proverbs 31:13

"She seeketh wool, and flax, and _____ willingly with her hands."

SHE IS RESOURCEFUL.
Proverbs 31:14

"She is like the merchants' ships; she _____ her food from afar."

She rises with purpose.
Proverbs 31:15

"She riseth also while it is yet _____, and giveth meat to her household,

and a _____ to her maidens."

She considers before making decisions.
Proverbs 31:16

"She considereth a _____, and buyeth it:

with the _____ of her hands she planteth a vineyard."

She is physically strong.
Proverbs 31:17

"She girdeth her loins with _____, and strengtheneth her arms."

She shines her Light.
Proverbs 31:18

"She perceiveth that her _____ is good:

her _____ goeth not out by night."

She is diligent to labour.
Proverbs 31:19
"She layeth her hands to the _____, and her hands hold the distaff."

She reaches out to others.
Proverbs 31:20

"She _____ out her hand to the poor;

yea, she reacheth _____ her hands to the needy."

She is covered by the blood of Jesus.
Proverbs 31:21

"She is not afraid of the _____ for her household: for all her household

are clothed with _____."

She is clothed in service.
Proverbs 31:22

"She maketh herself coverings of _____; her clothing is silk and_____."

She serves with her husband.
Proverbs 31:23

"Her husband is _____ in the gates,

when he sitteth _____ the elders of the land."

She delivers the Gospel.
Proverbs 31:24

"She maketh _____ linen, and selleth it;

and _____ girdles unto the merchant."

She is spiritually strong and honourable.
Proverbs 31:25

"Strength and honour are her _____;

and she shall _____ in time to come."

She speaks kindly.
Proverbs 31:26

"She openeth her _____ with wisdom;

and in her tongue is the law of _____."

She has no time for idleness.
Proverbs 31:27

"She looketh well to the ways of her _____,

and eateth not the _____ of idleness."

She is blessed and praised.
Proverbs 31:28

"Her _____ arise up, and call her blessed;

her _____ also, and he praiseth her."

She excels by Wisdom.
Proverbs 31:29

"Many daughters have done _____,

but thou _____ them all."

She makes choosing to fear the Lord her priority.
Proverbs 31:30

"Favour is _____, and beauty is vain:

but a woman that feareth the LORD, she shall be _____."

She leaves a legacy.
Proverbs 31:31

"Give her of the _____ of her hands;

and let her own _____ praise her in the gates."

She...

The Virtuous Woman serves as an example of what we should strive to become with the help of the Lord.

Memorize:

Proverbs 31:10
"Who can find a virtuous woman? *for her price is far above rubies."*

Apply:

How can you be more like The Virtuous Woman?

The Widow Of Zarephath

Read : 1 Kings 17

The Widow Of Zarephath

1 Kings 17:15

> "...she went and did according to the saying of Elijah: and she, and he, and her house, did eat many days."

SHE WAS DOWN TO HER LAST MEAL.

1 Kings 17:8-9

"And the word of the LORD came unto him, saying, _____, get thee

to Zarephath, which belongeth to Zidon, and dwell there: behold, I have commanded

a _____ woman there to _____ thee."

The Lord had commanded Elijah to come to Zarephath for one purpose…
so a widow could be used of God to sustain him.
When he saw her gathering sticks he asked her to fetch him some water.
He then asked for a morsel of bread, but she did not have a cake to feed him.

1 Kings 17:12

"And she said, As the LORD thy God liveth, I have _____ a cake,

but an handful of meal in a _____, and a little oil in a _____:

and, behold, I am gathering two sticks, that I may go in and dress it

for me and my son, that we may _____ it, and die."

SHE WAS HONEST ABOUT HER CONDITION.

He responded with a hopeful promise of what would happen
if she trusted what the Lord said.

1 Kings 17:13-14

"And Elijah said unto her, Fear not; _____ and _____ as thou hast said:

but make me thereof a little cake _____, and bring it unto me,

and _____ make for thee and for thy son. For thus saith the LORD God

of Israel, The barrel of meal shall not _____, neither shall the cruse of

_____ fail, until the day that the LORD sendeth rain upon the earth."

SHE SACRIFICED WHAT SHE HAD BY FAITH.

1 Kings 17:15

"And she _____ and _____ according to the saying of Elijah:

and she, and he, and her house, did eat _____ days."

SHE WATCHED THE LORD SUSTAIN THEM

DAY AFTER DAY.

Her obedience resulted in a miracle happening every time
she went to fix a meal until the day the Lord sent rain.
Imagine her fear the first few days...
then the excitement of seeing the Lord provide yet again.

1 Kings 17:16

"And the barrel of _____ wasted not, neither did the _____ of oil fail,

according to the word of the LORD, which he spake by Elijah."

She...

THE WIDOW OF ZAREPHATH SERVES AS AN EXAMPLE
OF THE MANY PROMISES GOD HAS MADE TO US,
IF ONLY WE WILL SIMPLY TRUST & OBEY HIM.

Memorize:

Ephesians 3:20
*"Now **unto him that is able to do exceeding abundantly above** all that we ask
or think, according to the power that worketh in us,"*

Apply:

What does the testimony of The Widow Of Zarephath mean to you?

The Woman In The City

The Woman In The City

Luke 7:37

"...she knew that Jesus sat at meat in the Pharisee's house..."

SHE WAS AWARE OF HER CONDITION.

SHE CAME FOR ONE REASON.

She knew that Jesus was in the house of Simon the Pharisee.
She knew enough about Him to provoke her to come to where He was.

Luke 7:37

"And, behold, a woman in the city, which was a _____, when she knew

that Jesus sat at meat in the Pharisee's house, brought an alabaster box of ointment,"

SHE DID NOT COME EMPTY HANDED.

She purposefully brought an alabaster box of ointment.

Luke 7:38

"And stood at his _____ behind him weeping,

and began to wash his feet with tears, and did wipe them with the hairs of her head,

and kissed his feet, and _____ them with the ointment."

SHE HAD FAITH IN WHO JESUS IS.

She wept over her sin at the feet of the Saviour.

Luke 7:39

"Now when the _____ which had bidden him saw it,

he spake within himself, saying, This man, if he were a prophet,

would have known _____ and what manner of woman

this is that toucheth him: for she is a _____."

Simon questioned what she did.

Just like us...

SHE WAS A SINNER IN NEED OF A SAVIOUR.

Jesus saw her faith, and forgave her of all that she had done.

Luke 7:47-48

"Wherefore I say unto thee, Her sins, which are many, are _____;

for she _____ *much: but to whom little is forgiven,*

the same loveth little. **And he said unto her,** *Thy* _____ *are forgiven."*

Christ forgave her sins when she came to Him.

Luke 7:49-50

"And they that sat at meat with him began to say within themselves,

Who is this that _____ *sins also? And he said to the woman,*

Thy faith hath _____ *thee; go in peace."*

She...

THE WOMAN IN THE CITY SERVES AS AN EXAMPLE OF HOW WE CAN COME TO JESUS AS A SINNER IN NEED OF A SAVIOUR, AND HE WILL FORGIVE US.

Memorize:
Ephesians 2:8-9
*"For **by grace are ye saved through faith**; and that not of yourselves: it is **the gift of God: Not of works**, lest any man should boast."*

Apply:
Do you think The Woman In The City is mentioned in any other passage?

Be A Woman Of The Bible

Be A Woman Of The Bible

Did you know that there are three distinct ways to understand the Bible?

READ
Deuteronomy 17:19

SEARCH
John 5:39

STUDY
2 Timothy 2:15

You have studied the lives of 12 Women of the Bible.
Their names or testimonies are recorded on the pages of the Word of God for specific purposes. The characteristics of their lives are examples of the many things you can choose to apply to your life.

Although your name is not printed in the canon of the Scriptures, you can still be known as a Woman of the Bible by purposing yourself to use the qualities of their lives to affect how you walk with the Lord.

The Book of James describes two different choices you have
in your response to what you find in the Word of God.

James 1:22-25
"But be ye doers of the word, and not hearers only, deceiving your own selves.
For if any be a hearer of the word, and not a doer, he is like unto a man beholding his
natural face in a glass: For he beholdeth himself, and goeth his way,
and straightway forgetteth what manner of man he was.
But whoso looketh into the perfect law of liberty, and continueth therein, he being
not a forgetful hearer, but a doer of the work, this man shall be blessed in his deed."

LIVE OUT WHAT YOU KNOW.

If you are to be known as a woman who follows Biblical Truth,
you have to live out what you know.
"doers of the word, and not hearers only"

There is a difference between what you know and what you believe.

Many people who call themselves "Christians" know Biblical Truth.
They know that Jesus Christ was the Son of God.
They know that Jesus died on the cross.

They even know that He died on the cross of their sins.
They know a lot of things...but have they believed on Him?

**There is a difference in knowing something,
and actually believing, or placing your faith in it.**

Many have heard the phrase that "people can be 18 inches away from Heaven".
The principle found here is so true.

Many know that Abraham Lincoln was the 16th President of the United States of America. Many even know that he famously spoke the Emancipation Proclamation, and that he led the abolishment of slavery.

They have never met him, yet they know many things about him.

There are many people that know countless facts about Who Jesus is, yet they have not placed their faith and trust in what He did on the cross for them.

That is the difference.

LIVE OUT WHAT YOU BELIEVE.

The same principle applies to the women you have studied throughout this book. You can know everything about their lives, so much so that you could clear the "Women of the Bible" column on the Jeopardy board, but if you do not apply what you know to your life it simply ends with knowledge.

You can know many many things found within the pages of God's Word, but if you only hear them without being a doer of those Truths, the Book of James clearly says that you are deceiving yourself.

Be A Woman Of The Bible

References

References

ABIGAIL
"Cause of Joy"

1 SAMUEL 25:1-42

2 SAMUEL 3:3

BATHSHEBA
"Daughter of an Oath"

2 SAMUEL 11:2-3; 12:24

1 KINGS 1:11-31; 2:13-19

1 CHRONICLES 3:5

DEBORAH
"Bee"

JUDGES 4 & 5

HEBREWS 11:32-34

LYDIA
"Bending"

ACTS 16:12-15, 40

PHILIPPIANS 1:1-10

MARTHA
"Master"

LUKE 10:38-42

JOHN 11 & 12:1-3

MARY OF BETHANY
"Trouble or Sorrow"

MATTHEW 26:6-13 - MARK 14:1-9

LUKE 10:38-42 - JOHN 11 & 12:1-11

MICHAL
"Who is like Jehovah?"

1 SAMUEL 14:49; 18:20-28; 19:11-17; 25:44

2 SAMUEL 3:13-14; 6:16-23; 21:8

1 CHRONICLES 15:29

PHEBE
"Pure or Radiant"

ROMANS 16:1-2

THE SYROPHENICIAN WOMAN

MATTHEW 15:21-28

MARK 7:24-30

THE VIRTUOUS WOMAN

PROVERBS 31

THE WIDOW OF ZAREPHATH

1 KINGS 17:8-24

LUKE 4:25-26

THE WOMAN IN THE CITY

LUKE 7:36-50

About Us

About Us

*"Delight thyself also in the LORD;
and he shall give thee the desires of thine heart."*
Psalm 37:4

From this verse comes the inspiration behind the name of this ministry. It is a reminder that if we delight ourselves in Him, He promises to give us desires according to His will for our lives.

In 2012, the desire for a design ministry began. The Lord has since opened door after door to allow that desire to become a reality...*"Commit thy way unto the LORD; trust also in him; and he shall bring it to pass."* Psalm 37:5

Delight Thyself Design Ministries began as a media ministry at Teays Valley Baptist Church of Hurricane, WV. Then Lord directed us toward reaching people with the printed Word of the Gospel. A tract ministry was born, and has since continued to grow as the Lord leads. In 2014, we began shipping tracts to missionaries across the world with little or no material with which to reach their field. **Please pray with us** that the Lord will continue to provide resources to print the tracts the missionaries are requesting.

We ship tracts free of charge to anyone willing to distribute the printed Word of the Gospel of Jesus Christ. Contact us if you would like to receive a sample pack or box to distribute.

Gospel tracts customized with a church's contact information are a great way to spread the Gospel and allow others to contact your ministry. We also design custom material for Independent Baptist Churches, which helps fund the printing and distribution of Gospel tracts which are sent across the world.

We are so thankful for those whom the Lord has provided to support this ministry on a monthly basis or through one time donations. If it were not for the Lord using these generous people, this ministry simply could not exist today. We claim Philippians 4:17 for this method of support, *"Not because I desire a gift: but I desire fruit that may abound to your account."*

If you would like to receive ministry updates, follow us on social media or send us your email address to receive our newsletters.

Delight Thyself
DESIGN MINISTRIES

delightthyself.com

What Can One Tract Do?

One tract was sitting in the office of the home of a young man named, Hudson. When he found it, he read over it and the phrase "the finished work of Christ" began to work on his heart about his need for salvation. He then surrendered his life to Christ, and was burdened for the people of China. This man was who we now know as Hudson Taylor, the missionary who brought the Good News of the Gospel to China.

One tract was given by a friend to a man named Joe. Over the next several months, the Lord used that tract to put him under conviction, cause him to go to church and walk the aisle to trust Christ as His Saviour. When he got up, he saw his pregnant wife beside him. She had also came forward by faith to accept Christ. This is the testimony of the parents of the founder of this ministry. One tract led to their salvation, a Christian heritage, and the start of this ministry. Without God using a man to give that one tract, this ministry would not exist today.

One tract has now yielded nearly 2,000,000 tracts to date being sent all across the world, and only heaven will reveal the fruit that remains. To God be the glory, for great things only He hath done.

Isaiah 55:11
"So shall my word be that goeth forth out of my mouth:
it shall not return unto me void,
but it shall accomplish that which I please,
and it shall prosper in the thing whereto I sent it."

Will you allow God to use you
to spread the printed Word of the Gospel?

Visit delightthyself.com for more resources.

ONE TRACT
CAN
MAKE A
DIFFERENCE

The Bible Way To Heaven

*"Jesus saith unto him, I am the way, the truth, and the life;
no man cometh unto the Father, but by me."*
John 14:6

We Are All Sinners.
"For all have sinned, and come short of the glory of God."
Romans 3:23

We Were Sent A Saviour.
*"But God commendeth his love toward us, in that,
while we were yet sinners, Christ died for us."*
Romans 5:8

We Were Supplied A Gift.
*"For the wages of sin is death;
but the gift of God is eternal life through Jesus Christ our Lord."*
Romans 6:23

We Can Simply Confess & Call.
*"That if thou shalt confess with thy mouth the Lord Jesus,
and shalt believe in thine heart that God
hath raised him from the dead, thou shalt be saved.
For whosoever shall call upon the name of the Lord shall be saved."*
Romans 10:9,13

It's that simple.

The Bible says... **Whosoever.**

Once you see yourself as a sinner, if you will simply *"call upon the name of the Lord"*, you can be saved from spending eternity in the Lake of Fire separated from God. You may say..."It's not for me." or "I'll never be good enough.", but God said... **Whosoever.**

God is not willing that any should perish.
That includes you.

If you have trusted Christ as your Saviour,
or would like more information, please contact us.

delightthyself.com

Printed in the USA
CPSIA information can be obtained
at www.ICGtesting.com
LVHW061831311023
762341LV00006B/14